Kim

Kim -

Les Touristes allemands ont bien applaudi
"Fraulein Kim Harlow" me voilà devant
place Blanche à une terrasse, un garçon
est passé, puis a pris une table près de la
mienne, je sais que le coca n'est qu'un
pretexte et qu'il va bientôt me parler,
comme toujours je suis partagée entre l'orgueil
et la gène, bien sûr je suis fière de séduire,
je commence même à me sentir rassurée
mais autre chose intervient dans ma tête,
sait-il? se doute-t-il? ou ignore-t-il
complètement, et moi dans tout ça, moi
qui ai toujours recherché la vérité, me
voilà confrontée à ce dilemme, j'ai
l'apparence d'une femme, j'ai tout fait
pour ça, jusqu'à changer de sexe ...
les années ont passé et je sais aujourd'hui
que je ne serai jamais une femme, homme?
je ne l'ai jamais été, il me reste à assumer
ma vie de "Transexuelle".
Le garçon me demande gentiment s'il
peut me tenir compagnie, je m'invente
un rendez-vous, je le regarde partir vers
le "Moulin Rouge" seul, comme moi.

Kim Harlow / Bettina Rheims

Kim

Translated from the French
by Paul Gould

Gina Kehayoff
Munich

The royalties from the sale of this book shall be donated to
ARCAT-SIDA *and the Institut Mérieux, Paris.*

For information please write to the publisher:
Gina Kehayoff Verlag
Holbeinstrasse 4
D-81679 Munich
Germany

Designed by Peter Langemann, Munich
Duotones by Karl Dörfel, Munich
Printed and bound in Germany
by Sellier Druck, Freising
ISBN 3-929078-21-X

Kim Harlow was unable to finish her story. Her last lines are about a friend of hers who fell to AIDS. *And it was that illness which cut short this work, her work. She entrusted those close to her to finish, fully aware that her days were numbered. We put together her notes, tape-recorded and written down. Not a word was crossed out in her chapters, written in a single, incisive outpouring. True to life. The word that flows most often from her pen is… truth.*

With all our love, Her mother, brothers and sisters.

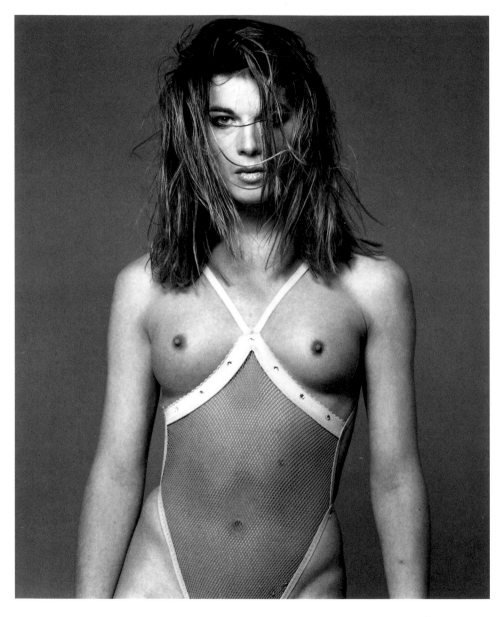

January 1990.
First photo session in my
studio for Modern Lovers.
Kim is the books Espionne.
Beautiful, funny – she goes
further than others, and we
have become good friends.

B. R.

When I was twelve and decided to have my ears fixed, to have them pinned back, my mother was worried. She was troubled by the whole thing and wondered – she told me afterwards – she wondered how far it would go. And in fact, I think she had understood how big the problem was, which went much further than just having my ears fixed, of course.

I could feel the desire to change – though I couldn't express it – and I was starting on the long road to becoming a woman.

One day my friend Louis 'phoned me – I'd asked him to – and he'd arranged a meeting for me with Bettina Rheims – perfect timing, because she was just interviewing models for her book *Modern Lovers*, and she was looking for androgynous people. So I went along to see Bettina hoping that she'd choose me for her book, because I really wanted to pose for her. I didn't get my hopes up, because I was really – I still am, but I was even more so at the time – I was really self-conscious physically, and I didn't think such a great photographer would like me. We got on really well when I went to see her, and she decided to take photos of me. We did the photos, and for me it was a really great experience, so exciting. Something really clicked between us, and there was a sense of professionalism which I'd rarely felt before, even though I'd had the opportunity to appear on stage and do all sorts of interesting things. After the shoot, I said to myself, OK, it was really nice, but it's over. It was a bit like when you have a lover who has made love to you all night and you know you're never going to see him again – I just thought it was over. So I didn't get back in touch with Bettina, and when she invited me to the exhibition and the opening, as well as the dinner, the party afterwards, I didn't go, because I thought that in the end my presence would be undesirable now that she'd used me, a bit like the way men act with women. But in fact I must have been wrong, because Bettina's a real, sincere per-

son, and she must have appreciated me more than I'd thought, more than I'd imagined. And then a few months later I was working as a peep-show stripper on the Rue Saint-Denis, and Bettina was walking along with her boyfriend and saw me, just by chance. I think she found the setting funny. We chatted for a bit. I felt really comfortable with her, and she invited me round to dinner the following week, and this time I went. After the photos for *Modern Lovers*, she suggested something a bit scary. She said, "Listen, I'd like to ask you a favour. I'd like to take some photos of you dressed as a man." I was frightened at first, but in the end I said to myself, Why not? So I instinctively said yes, because it was Bettina, because I trusted her, and because I believed that she wouldn't use the nasty side and would make something beautiful out of it.

But I must say it frightened me anyway. And so the next time we met I brought it up, I said to her, "You know those photos? Do you still want to do them?" And she said, "Yes, we are going to do them, and we're even going to go one better. We'll do a whole series telling your story."

And this beautiful series of photos that Bettina took does tell my story, but backwards. First you see me looking really feminine and sensual, going out, walking around in a big hotel, then in my room in a négligée, in my lingerie, then naked, then bit by bit you see me gradually lose my composure and cry. You see me taking off my make-up and at the end I'm dressed as a boy. The pictures are very beautiful – they're not autobiographical, but they all have something in them that I've lived through. When I saw them I said to myself that they were a kind of sublimation of everything I'd experienced, it was really… I can really see myself in them. A wonderful gift from Bettina.

At the shoot for that series, when I was naked, there was a feeling of excitement among the make-up people, the hairdressers and the stylist.

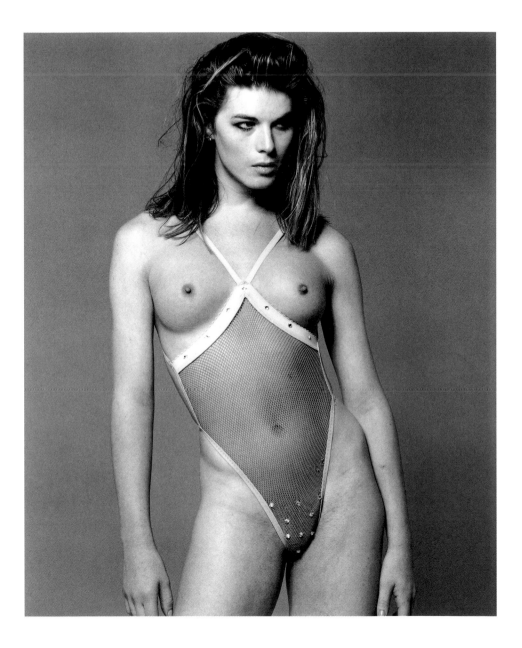

But the most emotionally-charged moment, when everyone was quiet, was at the end of the session when we did the photos of me dressed as a boy. It was funny, because that was the moment when people – the crew, the people at the shoot – were the most excited, much more than when I was naked or looking all glamourous. When they saw me like that, dressed as a boy, they were all a bit excited. I was too, but I wanted to tell them, "Don't worry, it doesn't matter, it's not that hard for me." Because in fact it was a bit hard, but at the same time it was artificial, and I knew that even though it was me, it was really somebody else. It was good that all my experience was behind it – I was just acting, and I was really having fun… and it was exciting, and moving to see… to see how I behaved towards Kim dressed as a boy.

Well, this might seem shocking, but I must say one very important thing, so that you can see who I am, the person I am today. The truth is, I'm not a woman. Of course – and this is going to shock others like me, and astound some people – you might wonder, why do all that, just to say at the end that she's not a woman? Well, it's quite simple really. I was a boy who felt so terrible in his boy's body, because in my head, in my mind, I felt completely female, and I really needed to… I was incapable of living the life of a boy, of a man, and I didn't feel like a man at all. So I did what I had to, bit by bit, and it took a long time and was really hard to… I did what I had to do to be in harmony with my mind, ie to look like and live as a woman. But then it'd be wrong to say that today I'm a woman. I'm a transsexual, and what makes me a transsexual is that I was born a boy, and I changed so as to become someone physically totally female, with a physique which goes with my mind. But the problem is, when you say to someone you're not a woman, they say you're a man. No, I'm not a man either, I'm a transsexual.

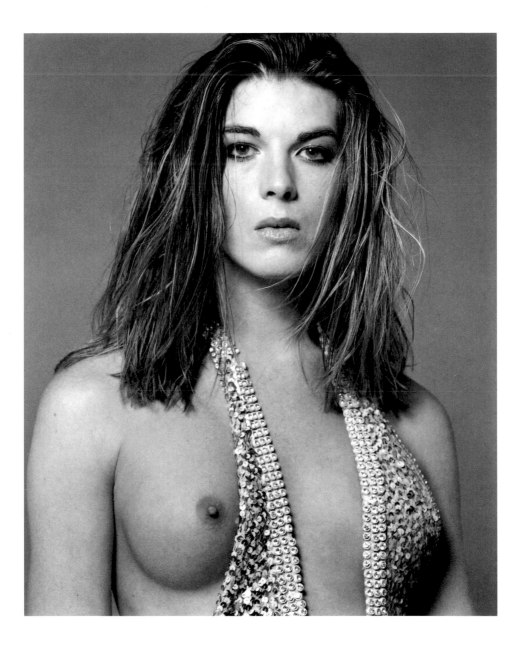

The older I get – I'm still fairly young – the older I get, the more I feel the need for truth, the need to say things as they are. And I think that when you're really honest, the truth is easier for people to understand, and I hope that people will understand better what I've got to say, now that I'm trying to purge my story of anything false. Well, apart from that, I do like fictionalising a bit, because I think that by fictionalising you can get nearer the truth. But I don't know, I've only just begun, but I think I'll fictionalise a little bit because... because let's face it, who's going to care if my dog pees on the landing and my neighbour has a go at me? There are much funnier stories to tell which are still part of a certain reality without being boring, everyday stuff. So I think that you can find authenticity in fictionalised acounts, like in these photos. They were not photojournalism or anything, they were posed, they were worked on. But still something real comes out of them.

The other day, I was lying naked on my bed, and a man was calmly getting dressed. He said to me, "You know, you're a very beautiful woman." Naturally it was very nice of him, but I think it was sensitivity that made him say that. I think he was aware of the insecurity I can still sometimes feel about my... my appearance. But despite the arrogance I can display in public, and the airs I put on, this image that people think is very solid, I'm still very fragile, because everything happened so quickly, and quite honestly I didn't think I'd ever be taken for a woman, a credible woman, and when I started my hormone treatment a few years ago, I really expected to go through all sorts of sordid, ugly things. I saw myself serving drinks to sailors in some dive in Germany – early 40s thriller stuff. I saw my face ravaged by drink, a wig put on askew, stockings with holes in them. Really awful. And I thought nothing else was waiting for me, I had no other future. But I took the plunge anyway.

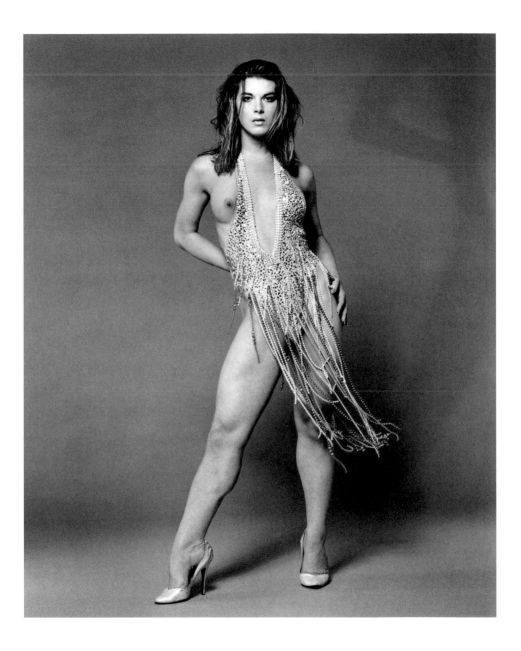

I took the plunge because nothing could be worse than what I was going through. My life was so unbearable. You have to understand that even though I had at the time a good job, a nice apartment and the appearance of a totally normal boy, my life was hell. I really was living in hell. I've undergone things that would seem like hell to others, but it was less of a hell than what I was living through before. And thank God, all that changed, and I soon had a pleasant life with my new appearance. But I really was ready to go through the worst to be able to live in my truth.

And what I'm doing now is precisely that – telling the truth. I think that in the end many people move away from the truth, and I think that you've got to get closer to it and play that card. Funny – that's just what Bettina said to me at our first meeting: "In life you have to play with the cards you've been dealt." The cards I've got are my life, my experience, and keeping to the truth as much as I can. It's a shame only a few people play those cards – it's the only way for me to manage to be fulfilled and to feel good about myself. And today, if I find it easier to make connections with people and things, I think it's because I'm finally living in my truth. That's the result of long, hard work, because I haven't always lived truthfully. I think that's more the case now. And will be still more in the future, I hope.

Other transsexuals often reproach me for being too far out on the fringe of things. In fact, I think it's just the opposite. I'm not at a distance – on the contrary, I refuse to distance myself, that's why I avoid the transsexual ghetto, which is itself more or less mixed in with the transvestite ghetto. That shouldn't be the case anyway, because transvestite and transsexual are two completely different things. What's more, I don't feel at a distance. I just live my difference in my own way, with-

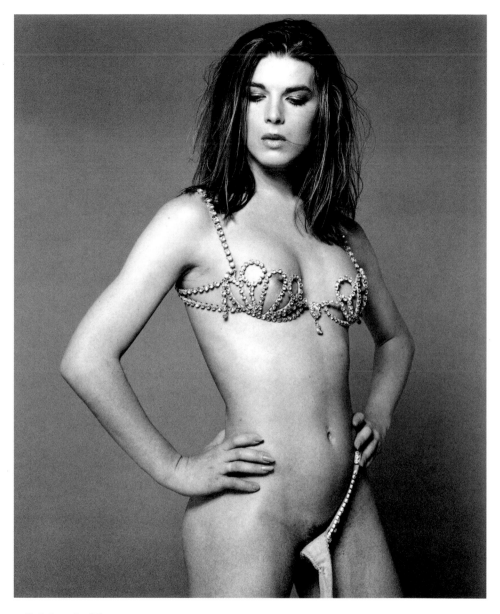

*A little later, I tell her
of my idea to capture with
pictures her transformation
into a boy. Kim will take
one year to consider.* B.R.

out seeking to deny that difference. My difference has its own value in the more "normal" circles, heterosexual, homosexual and transsexual circles because I don't see any reason to feel identical to others or to be surrounded just by people who have the same kind of history as myself. I'm not interested in that. For me that means locking yourself into a ghetto, and I can live my difference with all kinds of people. That's what interests me, that's what helps me grow.

I think there's one thing about us transsexuals that terrifies men, and that's the deliberate decision we have made to have the operation – the fear of castration. Obviously, they just can't understand it, since we've got nothing in common psychologically. But they're terrified by the idea that a boy, ie someone physically just like them, has deliberately decided to undergo this castration. It took me years to get used to looking at the other dancers who hadn't really understood my change, even to face them, because it was something only very few people understood at the beginning, and today, when I meet young dancers who are now going through something like what I went through about ten years ago, they are really nice, and look on me as… well, as a dancer, but also as someone a bit special. But I feel it's something they respect, and that's something I'm very proud of.

I grew up in the world of dance, so the image of the body is very important. I'm one of those people who are terrified of mutilation – losing a leg would be the most terrible thing, because I visualise my body as a whole. But the operation was quite different because my penis bothered me, it was something extra, a part of my body I didn't want, and that I repressed completely. I couldn't stand seeing myself naked in the mirror and seeing that penis, I just couldn't. But now I take pleasure in seeing myself naked in the mirror – I look just as I should be.

In the months before my operation I had lots of dreams. I would always see my body down to the waist, a woman's physique, a woman's body with a small bust, but I never saw what was between my legs. When the operation was a matter of weeks away I dreamed of the operation, and the dreams were painful because in each dream I was being operated on in one way or another, and each time the operation never came to an end. Something always stopped it from finishing, and each time... I never saw my crotch. I knew I was being operated on, but it was always being interrupted, it just never finished. And after the operation, in the first dream I remembered when I first came to, I saw my naked body – just as I'd imagined it, since I'd never seen it, I mean with a woman's sex – my body down to below the waist. It was the first time I'd visualised my body, and it was in a dream because I hadn't yet seen my sex.

I don't talk a lot about my father, mainly because my father never really looked after me, never played his part as a father, but also he made the decision not to see his children any more. That happened more or less immediately after my operation, but I wasn't the only child that happened to. He completely rejected his three children, so... I think that ultimately it's a good thing, a good thing to the extent that a father... Well, there's the biological father, but that's something else, that's the one who got your mother pregnant, but I think that in human relationships there's much more to it. It has to be much deeper than that, and if someone doesn't want... doesn't want to look after you, doesn't want to give you this love, maybe in the end it's better not to see that person. Because for years, up until the operation, I was always in need of affection, in need of money, and I was always asking my father for something because in fact I was asking for the love I never got. Today I know I'll never get it, I've come to terms with it, and I think it's better that way. Well perhaps –

no, certainly – that changes my relationships with men because I'm always looking for a man who'll protect me, no doubt because I'd felt such a strong lack of a father.

My mother is something else. I talk about her a lot, because she's someone who counts for a lot in this whole story, she plays a very important part, and has done for years. We were brought up worshipping her beauty, and it was really so hard for my brothers and sisters, especially for my sisters – it's not always easy having a mother who's very beautiful and lets you know about it. I, however, had a kind of access to this beauty in that I looked a bit like her. But in any case I think we were all affected by her regal self-confidence, and now we're all a little bit sensitive about it. I think that rightly or wrongly we are all a bit self-conscious about our bodies.

From my adolescence right up to my operation, or rather the months just before my operation, I just couldn't talk to my mother. There was this huge communication problem because I didn't own up about the whole thing and I was incapable of talking to her, maybe because she was too deeply involved in my story. Then when I finally made up my mind I was able to talk to her, and from then on our relationship went from strength to strength. Today we have a very special relationship, and I'm so happy about that.

In our family it was difficult when we were young. With a psychiatrist for a father and a psychoanalyst for a mother, it really wasn't easy at all. Paradoxically, I think I could have turned infinitely more neurotic than I in fact did. What's more, I need my neurosis. It gives me a spark for the show, for my career it's a real asset. For my private life, I think the road I'm following now by, among other things, trying to get my story down on paper, lets me get rid of my neurosis a bit and head towards

truth and authenticity, simplifying my personal relationships with those around me, and my love affairs. I hope.

Before I met Bettina, I was convinced my advantages in the seduction game were a question of technique, I mean my stage performances, my acrobatics, dancing, and so on, and… up to a point, my image. But with Bettina I understood that in the end it really is a question of image, because everything must come through in my image, including my personality and everything I had to say or express to people who were powerful and important, everything I had to make them feel. So thanks to her I made a lot of progress, and I don't know if she realised that straight away. Maybe now she knows, but in any case she's someone who's helped me so much to go forwards. That's why I'm talking about it, and why this story in a way is dedicated to her because… well, at least the telling of the story, because I'm sure I'd never have started anything at all if I hadn't met Bettina Rheims.

My earliest childhood memories are those of a child who was appreciated by all the people in our street, because I suppose I looked nice, and I was always hearing, "Oh, isn't he cute, isn't he cute!" That made me really conceited, because at a very early age I was getting lots of compliments, no doubt too many for a little kid. What's more I must have looked quite feminine, because I was often taken for a little girl. I was even nicknamed "Nana". Everyone called me Nana. It really makes me laugh now, but it was completely natural. Just everyone called me Nana. My little characters, my toys, were teddy bears and things. When, for instance, someone gave me a Babar, King of the Elephants, I made him into Queen Babar. It seemed the obvious thing to do. I made all my toys into females. They automatically did the same thing as me, so all my toys, male and female, ended up female whatever happened. And of

course I was attracted to girls' games. In music, too, my tastes weren't really what you'd expect in a kid that age. My tastes were a bit odd, and very early on I was attracted to music hall stuff. I'd discovered old records by Mistinguett and Josephine Baker, and it just fascinated me. I must have been all of seven or eight when I started listening to it. I remember one really humiliating moment. One day I went to play at a friend's house, and at some point I disappeared into his sister's room. I found a Barbie doll – I was completely fascinated by this sublime creature, and I played with her all afternoon, alone in his sister's room, and then, late afternoon, suddenly my friend came in with my mother next to him. He pointed to me playing with the doll and said, "Look what your son's doing." I suddenly felt guilty. I think it was the first time I'd ever felt guilty about my femininity, because this boy really acted as if I'd been doing something bad, and after that we didn't see much of each other, and when he saw me in the street, near school, I crossed the road because I was afraid he'd make fun of me. What's more he caught onto that very quickly, and really did make fun of me. When I got to secondary school it was even worse, because I was a bit ahead of the others and straight away I became the laughing stock of the whole school. I must have been about eleven at the time, and the kids who were a bit older than me took a dislike to me. So I felt really alone, and it was around this time that I stopped going to school, because I couldn't stand the environment, this manly world. The girls looked on me a bit like… like their child, and the boys rejected me completely, and I felt really out of place. So I started to play truant regularly, and that's when I started dancing.

My mother, who was always going to dance studios, because she liked it, would take me with her, and one day a teacher wanted to see if I had any talent for dance. I was so flattered that I was considered to be good

at something, and besides it was a world which didn't frighten me that much, and so I wanted to go on. So that's how I started dancing. I found a kind of balance in dance for years, and it even eased the pain, because dancing allowed me to live in my femininity without being rebuked for it. What's more, it's a rigorous and… and disciplined environment, which suited me down to the ground, because I'm a very disciplined person, so I did very well out of it, I did well out of it for a long time. It also meant that for years I didn't question myself. I think that if I hadn't done any dance, if I hadn't been involved in ballet, I might have started things moving sooner.

I just can't imagine not having undergone this change. It's inconceivable for me. I can't bear thinking, My God, what if I hadn't done it? What state would I be in now? I know for sure that I'd be a mess. So today, despite my pains, my problems, my troubled love life and all that, for me they're good things, because I know I'm experiencing them in the skin I want to be in. These troubles are perfectly normal. Otherwise I think they wouldn't just be troubles, they would make everything empty, completely empty. It's better to suffer than not to live.

I had a good number of relationships with men before, and… I just couldn't come to terms with them, because obviously for the most part they were homosexuals, since I wasn't a woman. I couldn't cope with a homosexual touching my body, I couldn't bear it, I was ashamed of it. What's more I couldn't ever say to anybody that I was a homosexual, because I didn't feel like a homosexual. I just wasn't. And all these encounters I had with boys were just one-off things, nothing more than sex. I could never have imagined having an ongoing relationship with a homosexual, and anyway I've never had any kind of relationship with a boy who was a homosexual, apart from one boy I met about ten years

ago, and who I stayed in contact with during my change. Even now I still see him – maybe he's the great love of my life. This boy has always treated me as a woman. I think he doesn't even remember what sex I had before, for the simple reason that it never came into our relationship, neither physical nor emotional. He's always had a special place in my life, but now he's even more important to me than before because… Well, I feel good, and he can sense that I feel good, and things between us are better than ever.

I'm very wary of men who come up to me and try to chat me up, because in a lot of cases they're aware of my difference and see me as some kind of fantasy figure, an image, a sex object. Well, I'm a dancer, I appear on stage, I'm sexy when I sing and perform, and so I make them fantasise. But being a transsexual means it's a double fantasy. So it gets… I end up being just a walking fantasy. This is really hard for me, because I'm so wary, so reticent towards these men who come up to me – even aggressive, but I try to keep that under control. I'm not aggressive by nature, and I'm someone who's trying to find peace, and so obviously my aim is not to be aggressive with people. But now and again they come on so strong, they're kind of attracted and repulsed at the same time, and some of them are just sleazy, so it's difficult not to give in to your aggressive side.

If I go – I don't make a point of it, but it happens from time to time – if I go into a transvestite bar, they criticise me for being a woman, for having had the operation. And when I go out to a straight club, they come up to me, making it quite clear they know I'm not a woman. So I feel a bit like I'm between two stools, and it can be hard. Thank God, not that many people have had really stable relationships, and it's up to me to sort through them and choose, but encounters with… with stran-

gers are very complicated, because the matter of "you're this", or "you're that" always comes up very early on. I'm not really sure if you're supposed to… my aim is to be honest, so I want to talk about it, but at the same time talking about it is playing their game, because very often there's a kind of sick curiosity. So I don't really know, I think that in the end you should be upfront and say exactly what you are, just say you've had the operation, you're a complete transsexual, end of story. I think that's the best solution, and when you're with people you really want to talk to, you can bring it up when… when the time is right.

As I've already said, some men – well, most men really – are a bit uncomfortable with us because we've decided on this voluntary castration. The idea of the operation really scares them. But contact with women isn't all that easy either, because the femininity in us, which is really strong, kind of challenges women's own femininity. Many women find us fun at first, and then they suddenly get worried – they realise that the feminine impact we have might be even stronger than theirs, and this can make them aggressive. So it's really complicated to be at ease with men, to be at ease with women, and to be at ease with homosexuals. Lesbians and gay men, if they feel good about who they are, that's fine. But if they've got some kind of identity problem, and they tend to go for very feminine men or very masculine women, it complicates things even more, because they wonder… Well, they say to themselves, She's really come to terms with her femininity, and I haven't come to terms with my femininity or my masculinity, depending on whether it's a gay man or woman. So there aren't that many people left who you can get on with easily, except maybe the people who feel good about themselves and who, well, maybe not necessarily feel good about themselves, but who like me have come to terms with what they are.

*February 1991.
Kim was ready to become a
boy again for me. With the
help of a hairdresser, make-
upartist, stylist, she reinvent
Alexandre. In a pinstriped
suit she leaves the bathroom
of a hotel, her hair pulled
back; a moving and painful
moment. She had always
refused to show me photos
taken of herself when she
was still Alexandre.* B.R.

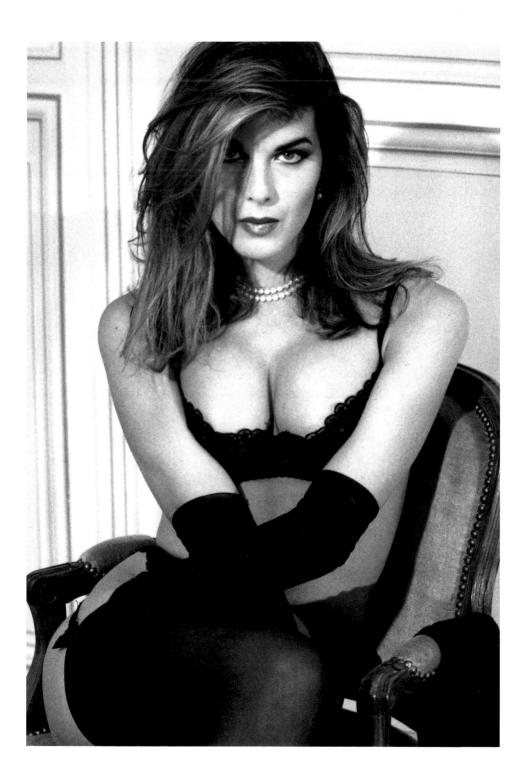

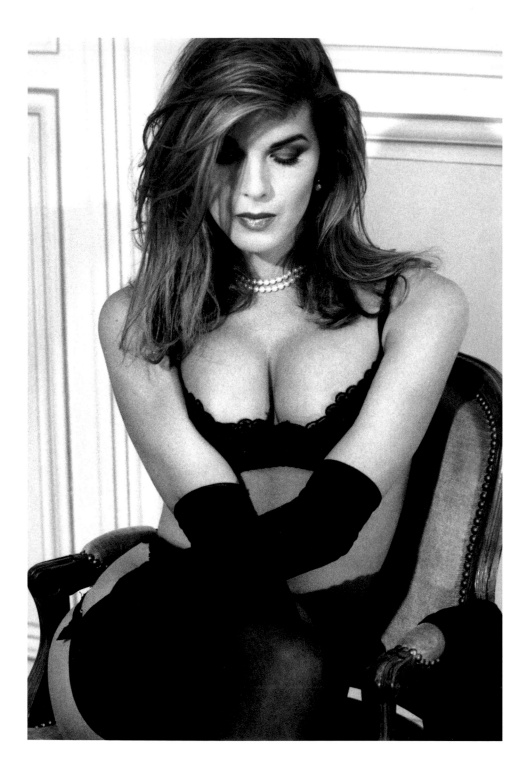

KIM

The German tourists gave an ovation to "Fräulein Kim Harlow".

So here I am on the terrace of a café on the Place Blanche, and this boy walks by, then sits down at a table near mine – I know that his Coke is just an excuse, and that he's going to talk to me any minute. As ever, I'm feeling a mixture of pride and embarrassment, but of course I'm proud of being seductive. I even start feeling reassured, but then something else pops into my head. Does he know? Does he suspect? Or is he totally unaware of it? I've always sought to be truthful, and here I am facing a dilemma. I look like a woman, I've done everything I could for that, even going as far as changing my sex. The years have gone past, and now I know that I'll never be a woman, or a man. I have never been either of these things, and I just have to come to terms with my life as a transsexual.

So this boy asks me politely if he might join me. I invent an appointment, then watch him walk away in the direction of the Moulin Rouge. Alone. Just like me.

In her last year,
Kim began to write, in order
to explain her life to others.

I had promised her this
book would be published,
without knowing she would
then no longer be alive.
B. R.

RÉGINE (My Mother)

My grandfather worshipped his brother Roger, who died young, a hero's death in World War I. In his memory the first child – he had wanted a boy, but it turned out to be a little girl – was named Régine. That was my mother. Long before me, she had felt the desire to belong to the other sex – after all, how else could you please a father who had so desperately wanted a boy? She even went as far as behaving like a little boy with her school friends.

She looked rather Anglo-Saxon with her freckled face, and my grandmother despaired because she didn't find her very pretty. In fact, physically, she was mature for her age, and she was soon a roaring success at her first dances. When she was five she spent a year in Paris with her grandparents, who took her to ballet classes. Unfortunately this passion was cut short when she returned to Marseilles. The same thing happened with her studies – at that time girls got married and brought up children. She was even afraid of her own hot temper, and she accepted the first proposal of marriage she got. So at barely nineteen she became Madame Robert Giraud. At twenty-four she was already the mother of four children, and was bored to tears with her stick-in-the-mud husband. Then she met a cousin of her husband's – Henri was his name – and it was love at first sight. Henri was also married with a son, but nonetheless they became lovers. A little boy was born and was named Franck. Officially he was Robert Giraud's son, but his father was in fact Henri Giraud. In the end my mother left her husband and children to be with Henri in Marseilles. Henri himself left his wife and official son, and poor Franck was left with Robert, not knowing that he wasn't his father. All this scandalised their middle-class families in Marseilles, and they dis-

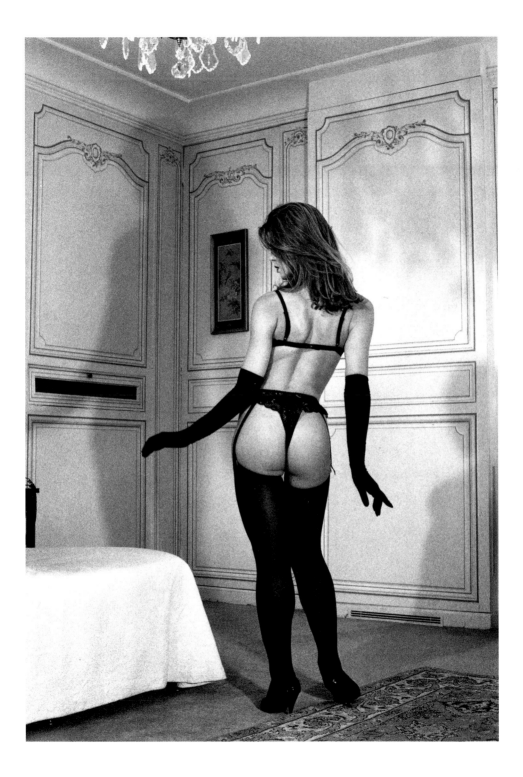

owned my parents. These were the circumstances, out of wedlock, in which I was born. There was no question of me being baptised, as I was considered to be a child of Sin. No matter – Henri and Régine made a lovely couple, and I was a child born of their love. After lots of legal wrangles my mother got custody of my brother Franck. My eldest brother and my three sisters stayed near Paris with their father, and Franck and I – Franck was getting to know his new father – lived in Marseilles.

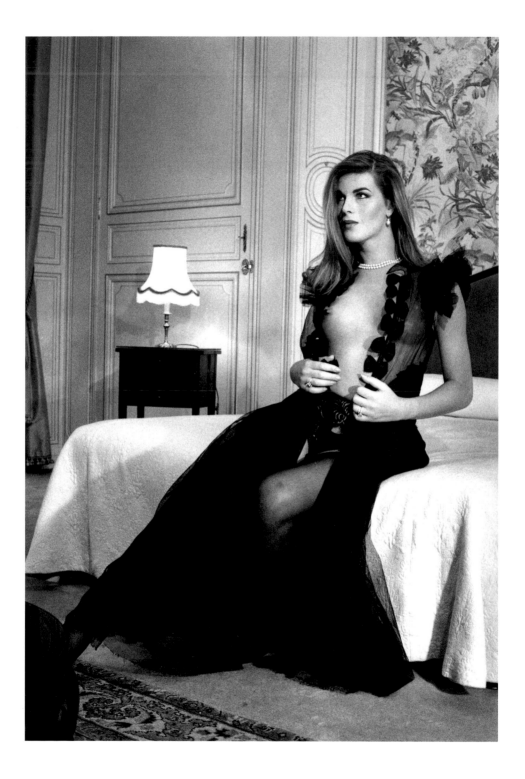

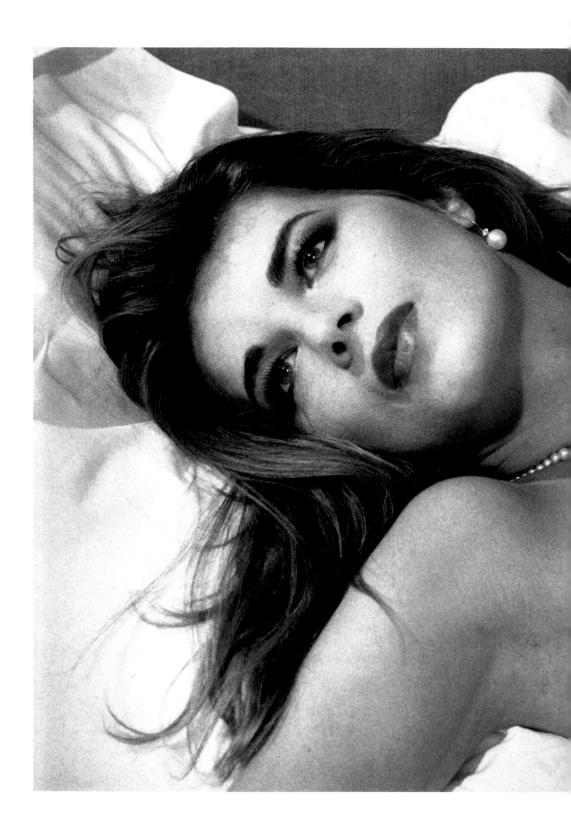

HENRI (My Father)

I don't think my father's mother ever kissed him.

The only thing I got from my father was his genes. I was always looking for love, and all I could do was ask for money. Nowadays, whenever a man spends money on me I feel reassured... and then worried. I think, Does he love me a little bit?

I think I love my father, and that he wanted to love me. Didn't he want a little girl after having two boys? Didn't I try to be his kind of woman, tall, blonde and sophisticated? He was obsessed by homosexuality, and when I told him I thought I was a transsexual, he said he was relieved because he had thought I might be a homosexual.

He was a neuropsychiatrist and worked for a long time on identity changes in transsexuals, so when I was a child I heard a lot about it. Why did he specialise in that field? Was it because of my latent transsexuality? Or was he attracted towards transsexuals himself?

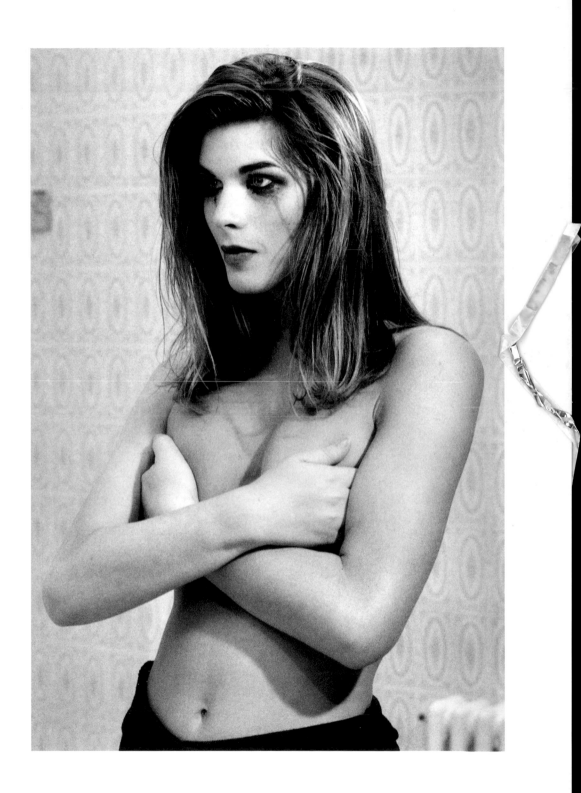

DANCE

When I was very young I would go with my mother to her ballet classes in a studio in an old building overlooking the Old Port. When you went into the building it smelled of boats and rotting fish, but when you got to the studio it was something else altogether. There were little girls dressed in pink, the old pianist, the teacher with her cane, and the pupils at the barre in fifth position. I would stay in the corner and wait quietly, watching this little world where I felt so at home. There was no question of me taking classes myself, because in our social circles little boys simply did not do that. Besides, my father would have been furious.

A few years later I went with my mother – still such a ballet fan – to another studio, and Catherine, the teacher, had the idea of trying me out to see if I had any talent. She was surprised to see that I was naturally incredibly supple – when I raised my leg, it went up to the ceiling – and my high instep was perfect for ballet. I was eleven at the time, and had no interest in anything. School was going from bad to worse, so you can imagine how pleased I was at seeing I had at least some talent for something. The teacher had little difficulty persuading my mother to let me start dance classes. My mother's relationship with my father was deteriorating and divorce was on the cards. So she made up her mind to send me to ballet classes, partly for revenge and partly through the repressed desire to launch me on a career that her family and upbringing had denied her. All this was kept hidden from my father, of course. My mind was already made up. I knew I was going to dance, and for me this pleasure was like tasting forbidden fruit.

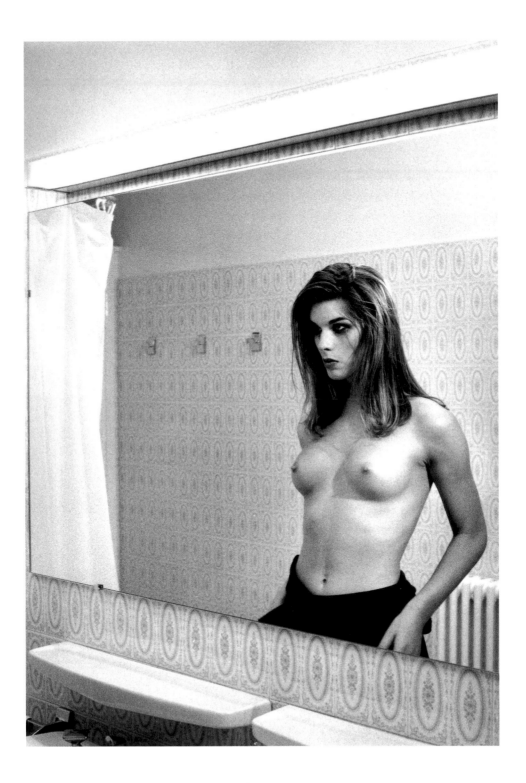

THE DISCOVERY OF SEDUCTION

When I first went out "as a woman" it was really hard. I was completely naïve and totally paranoid.

The first boy who tried to chat me up as a woman was a bit surprised that I was so cold, despite my sensual physique. I was convinced that it was all just a trick being played on me, and that he had just been dared to make fun of this poor creature. He in fact admitted to me later that he'd been disappointed at the brush-off, and hadn't understood my reaction.

The next one found me a bit more relaxed, and I'd decided to go all the way. I felt more of a woman than I ever had before. Later, at my place, when I was getting undressed in front of him – keeping my panties on so as to protect my image – he started to take me in his arms. And then the disappointment came. I soon realised he was more interested in my original sex than in my true femininity. Five minutes later he was out the door. He didn't understand my refusal either.

Basically my love life was hardly more successful in my new life. My experiences did no more than reinforce my desire to have the operation. Most people are horrified when you talk to them about this kind of opera-tion, and I must admit I surprised myself with my lack of apprehension about the act itself. After all, there's no turning back. Either I was ignorant – which was probably the case since I was so naïve – or I felt so lost and so distressed that only my instincts could save me. I daren't think what I would be like today if I hadn't made up my mind. Probably incredibly sad and withdrawn.

I started to go out as a woman all the time at the beginning of October after a few pathetic adventures, including one in which my lover went

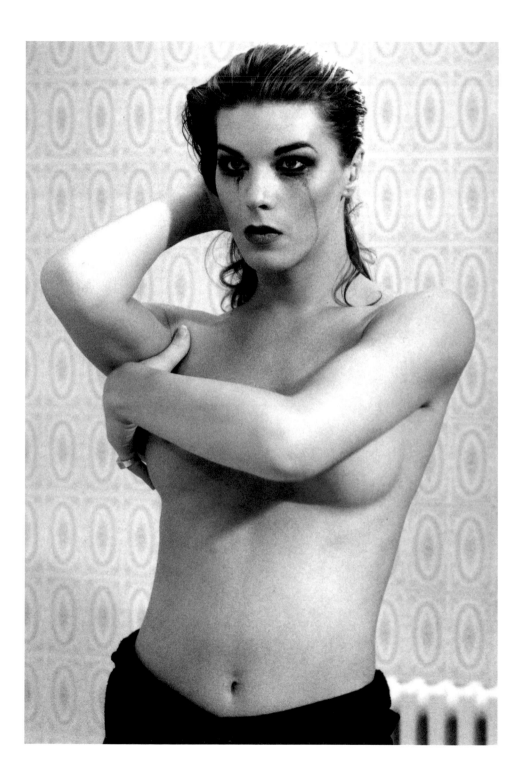

and got himself murdered the day we moved in together. Spiritually it was like being widowed on my wedding day. It must have been a sign that I wouldn't have an ordinary life.

I met Joseph late December that year. I'm sure that Joseph's interest in me came more from the fact that I had a decent income and an apartment than from my feeble attempts at seduction. However I think he was touched and above all very curious to follow my brand new transformation. Although the details needed polishing up I projected the image of being solemn and slightly androgynous, which I think he liked. We talked all night in a club in Saint-Germain, and I gave him my 'phone number. The next day he called me and suggested coming to see my show. Afterwards we went home together and there we slowly made love. From the word go he respected my femininity. At least, he didn't make a point of exploring to see what was between my legs. Later he accused me of having used him, and I denied it. He replied that it was true, and in the end I think he was right. I knew where I was going, and I needed at man at my side. I was gathering my strength for the big jump.

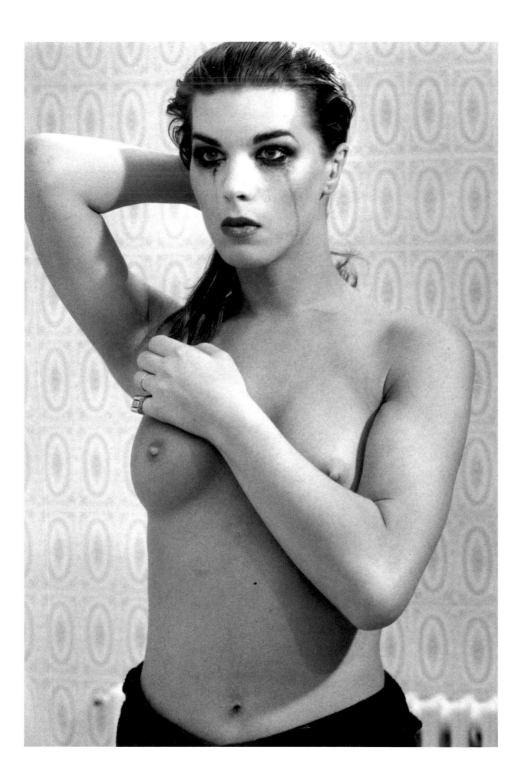

LONDON: DELIVERANCE AND CASTRATION

Having grown up in the world of ballet, where the image of the body is so important, I should have been terrified at the very idea of undergoing an operation which means castration. But that's a man's reaction. Although I never really hated my penis, since it was part of my body, the operation was essential for my mental well-being. I wanted my mirror to reflect the right image. I had no problem making up my mind, and the appointment was made for March 1988.

March 25, Dr Dalrymple's surgery. I ring the doorbell, feeling more timid than ever. A lady escorts me into a large room where there are some creatures from the year 2000 waiting. The minutes tick past, we all look at one another nervously. There's a group near me talking loudly in French. Suddenly the secretary shows an elderly gentleman into the waiting room. He looks like Michel Galabru, the actor. We look at one another, all thinking the same thing. The bitchiest member of the French group says out loud what everyone's thinking: "Does she want an operation? The doctor's going to have his work cut out!" Everyone bursts out laughing. I realise that everyone there speaks French, and the English drawing-room atmosphere suddenly seems lighter.

In the months before my operation I would have a lot of dreams. I would always see my body above the waist, ie I would see a woman's face and a woman's bust, but the image stopped there. Then I started to dream of the operation itself. It was horrific because I was aware of it, but each time the operation was interrupted, leaving me sexless.

The day after my operation, in my first dream I saw myself for the first time, naked and whole, with my woman's sex. It's funny that I was able to dream of the sex I had never seen – I was still wrapped up in bandages.

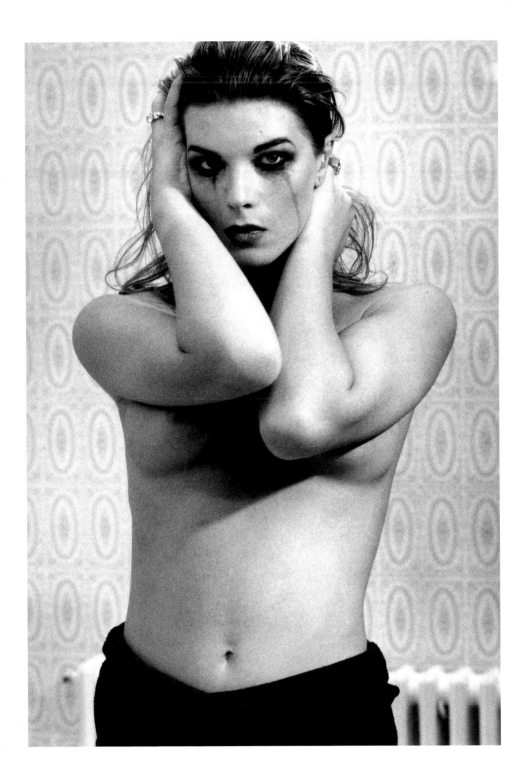

Sorry to disappoint you, but I can't tell you about the horrific pains which follow an operation of this kind. I just didn't experience them. Do they really happen? Or are they just the reaction to deep anxiety? I felt great, apart from the fact I was starving. I had to be content with tea and biscuits.

On the fifth day the doctor came to take off my bandages and take out the cylinder which was maintaining the vaginal orifice he had created. He was visibly pleased with his handiwork and said, "Oh, it's nice and deep!" Then he started taking lots of photos. I was a bit miffed that my first series of sexy photos was being taken in such an unglamorous setting.

The next day I was worried about what I'd seen that morning in my little mirror, and I asked the doctor to tell me why I had two holes. He told me that one was for sexual intercourse and the other was for urinating. I was flabbergasted – I'd never bothered to find out what a woman's parts actually looked like!

As soon as my bandages were off I started running up and down the corridors in front of the nurses, who were amazed at how fit I was. The doctor asked me to go and talk to a patient who had had the operation the same day as me, and was getting more and more depressed. So I went along to see the poor thing, and I understood straight away why she was in such a state. She was nineteen, and had come to have the operation on a friend's advice. And now she was wondering why she had done it. What could I say? I thought it was better to lie, and told her that now she was a woman like any other and that she should get it into her head that she always had been really.

A year later, I thought I wanted to do the same thing as her, and conform, wanting to believe that I had always been a woman. But that was impossible, and life soon proved that to me.

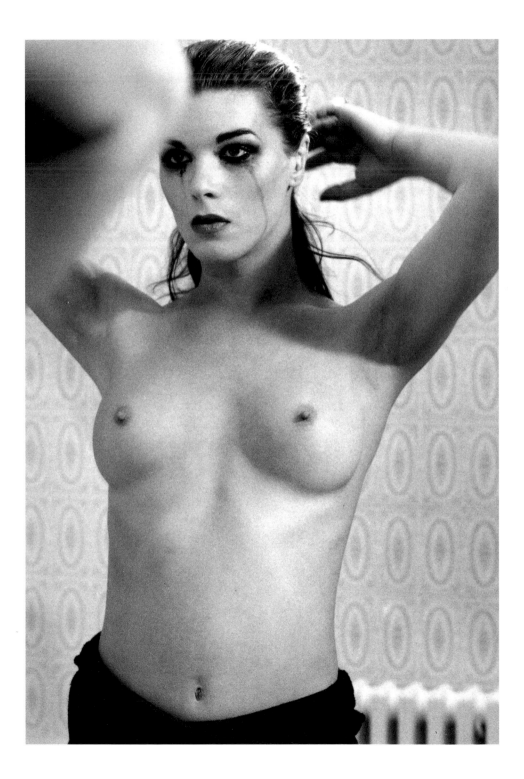

When I arrived at the clinic I got to know a young French girl called Dominique. She was petite, blonde and pretty, but boring. Nonetheless she was extremely feminine. She couldn't speak a word of English, and so she asked me to act as her interpreter. So I would often go into her room before her operation to help her communicate with the doctor and the nurses. We were operated on the same morning, and the following day I carried on acting as her interpreter, but by 'phone this time, seeing as we were both in such an uncomfortable position. The day the doctor took out the cylinders between our legs he gave me another two perspex cylinders of different sizes, to keep our new vaginal orifices open. Dominique was worried, and called me to ask what the point was of these two things. I was feeling a bit mischievous, and told her that one was for her vagina and the other… well, you can guess what I said. I think the poor thing would really have done it if I hadn't felt guilty and told her it was all a joke. I told her it would be better to avoid that kind of contortion – at least for a while!

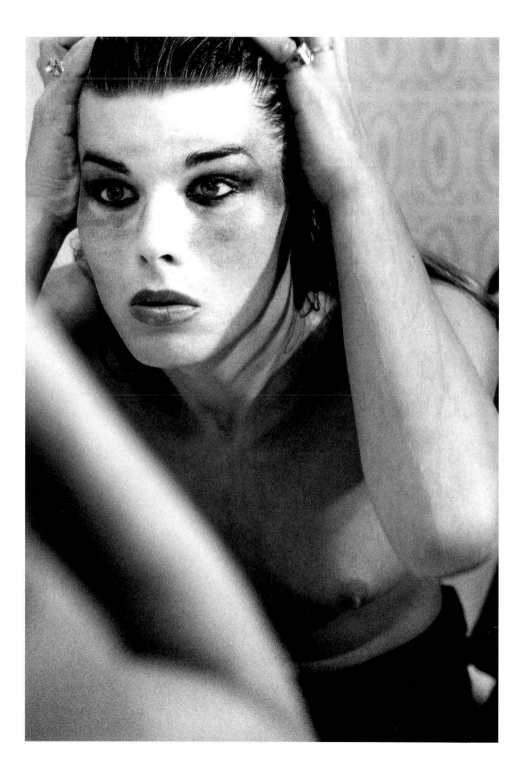

BETTINA

Bettina adored her brother. She looked a lot like him. He died a year before I met her.

I went to Bettina's when she was choosing models. She was looking for androgynes for her exhibition and book *Modern Lovers*. In fact I wasn't really what she was looking for. She needed feminine-looking boys and masculine-looking girls so that there would be a doubt. In my case there was no real doubt because my appearance is totally feminine. But somehow we clicked and Bettina wanted to take photos of me. We arranged to meet and that Sunday morning I was in the studio scared stiff, but at the same time really overjoyed, because I knew something important was going to happen in my life. When the make-up guy had finished with me I looked a mess. My eyes were all smeared, my mouth was crooked and my hair had been made all greasy. Bettina likes having her models look a bit under the weather, but even she took a step back when she saw me, and asked me to fix my eye make-up myself.

In spite of all that, I felt confident, and ready to give the best of myself. For this shoot, I had to forget my over-feminine self, and awaken the boy who is still a bit present inside me, whatever I do. I tried to use my eyes and my muscles to convey that, I wanted so much to give Bettina what she was looking for that for two hours I did nothing but exaggerate everything I'd fought against for years. The result is beautiful. sober and androgynous. I did nothing I was to regret later.

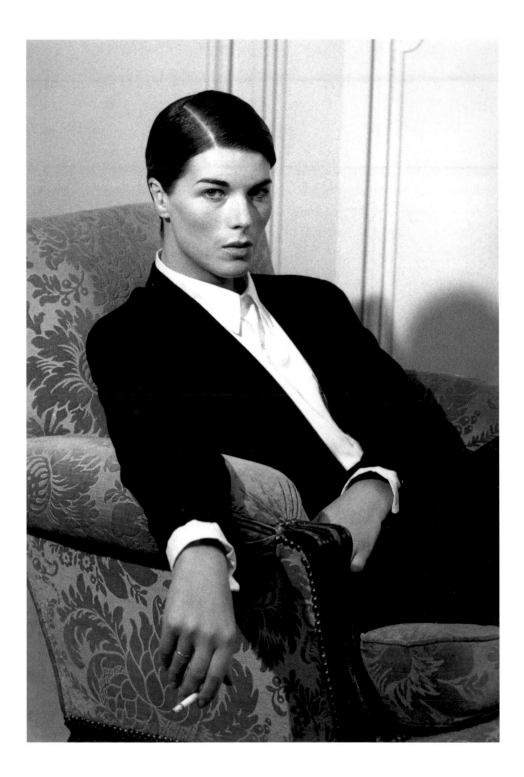

THE PEEP-SHOWS: CABARET AND CHAMPAGNE

Going into the game of seduction – or even soliciting – without the help of my show was as much an ordeal as a challenge. I have never been forced to do it, any more than I was forced to be a stripper in Pigalle. I've always felt the need to get close to the sordid things in life, maybe through masochism, but also no doubt through personal vice, because I was brought up in a middle-class family and then in the world of ballet, where everything seems so pure. I'll never forget that first night at the Moulin Rouge in Zurich – all it has in common with the Moulin Rouge in Paris is the name. I was sitting on a stool at the bar waiting for the customer. Three days earlier I had been dressed in feathers, sitting on an illuminated moon which set me down in the middle of the stage at the Alcazar in Paris – what a comedown! Never had a chief chorus girl fallen from grace so quickly! But I felt okay about it. It was necessary to punish myself like this, it would be good for me. I also needed to prove to myself in the middle of all these real women, without the make-up, without the dancing, and without the magic of a stage show, that people would still find me attractive. The customers all look the same in Switzerland, they look sad and austere like mediaeval engravings. It's really quite a feat to do your stuff in front of a clientele like that, especially when they can only speak to you in German.

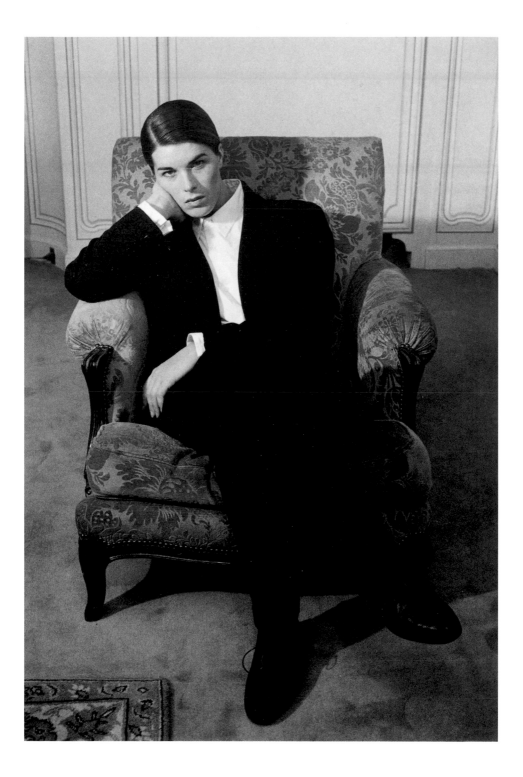

WOMEN IN PIECES, OR GIGOLOS IN PETTICOATS

The idea of a woman that some of the people like me have has always surprised me. Some key phrases keep coming back in conversation: "I've got to finish," "I'm not complete yet," and so on. If you ask what they're talking about, they'll tell you they've sorted out their face or their bust, but they need to have their "pussy" fixed. What's more they even talk about their bodies as if they were talking about a complete stranger. These girls won't say, "I'm going to have my bust changed," but rather, "I'm going to have the breasts done," or "the nose." You'd think they were always after something they could get through plastic surgery. I call them the "women in pieces". If you ask them if they feel like women, they'll say they will as soon as they have a 16 inch bust. One of them told me that she paid the surgeon an extra 10,000 francs under the table to give her a deeper vagina.

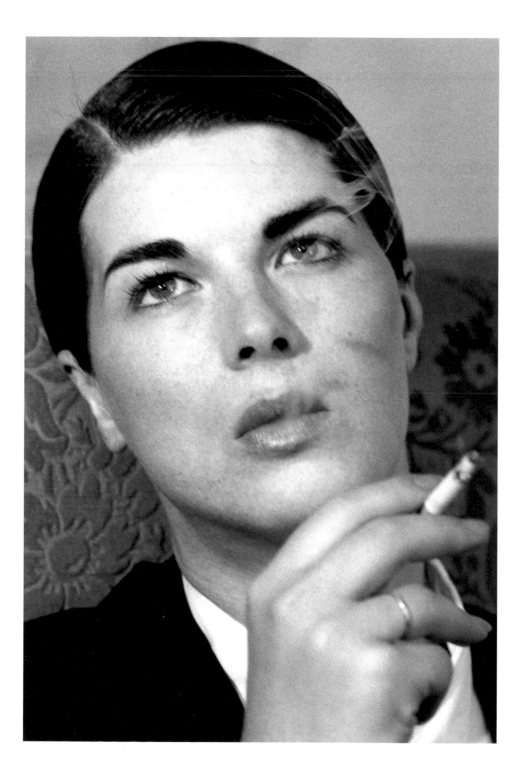

AIDS

How can one not talk about it?

I had to write because of AIDS. I miss Trévor, I knew, he knew, we talked little about it. He lived well for three years without treatment. He died in May with dignity, taken by throat cancer, quiet as always.

THE GREAT ADVENTURE

BLOCKADE COMING FROM THE SEA (MOTHER)

THIS CHILD THAT I WILL NEVER CARRY

CHILDHOOD

CABARET: LAS VEGAS, PARIS

LONELINESS

SUCCESS

Some chapters have only titles, they were never written.

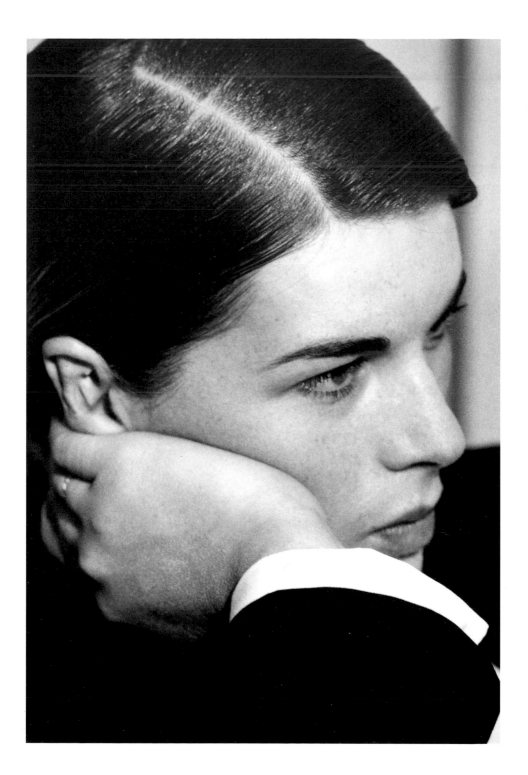